THE POCKET

Chappell Roan

Published in 2025
by Gemini Gift Books
Part of Gemini Books Group

Based in Woodbridge and London

Marine House, Tide Mill Way,
Woodbridge, Suffolk IP12 1AP
United Kingdom

www.geminibooks.com

Text and Design © 2025 Gemini Gift Books Ltd
Part of the Gemini Pockets series

Cover illustration by Natalie Floss

ISBN 978-1-80247-341-4

Manufacturer's EU Representative: Eurolink Compliance Limited,
25 Herbert Place, Dublin, D02 AY86, Republic of Ireland.
admin@eurolink-europe.ie

Printed in China

10 9 8 7 6 5 4 3 2 1

MIX
Paper | Supporting
responsible forestry
FSC
www.fsc.org
FSC® C020056

THE POCKET

Chappell Roan

G:

CONTENTS

Chappell Roan

Introduction

Welcome to the Pink Pony Club, a super-sparkly party hosted by 21st-century *femininomenon* – Chappell Roan.

For over a decade, this "brand-new" artist has been meticulously crafting and bedazzling her music, writing a killer catalogue of songs that not only seem to define the modern world we live in, but also defy it too. Her debut album, 2023's *The Rise and Fall of a Midwest Princess*, was as eclectic as it was entertaining, and as silly as it was substantial – and ready to change the world.

This pocket guide is a carefully curated celebration of all that's euphoric about the drag-inspired singer-songwriter, highlighting Chappell's unbelievable ascent from small-town obscurity to big-time superstardom. Where she goes next at this point is anyone's guess, but we know it will be one hell of a show!

Chapter One
Road to Roan

"If a five-year-old could draw a pop star, it would be me."

Chappell Roan, *Rolling Stone*, October 2022

Grammy Heights

In February 2025, Chappell's teenage prediction that she would one day win a Grammy Award came true. She bagged Best New Artist from a total of six nominations, a tally equal to her idols and peers, Taylor Swift and Sabrina Carpenter.

Chappell used her acceptance speech to demand record labels pay a living wage for developing artists, concluding in the now-iconic line that earned her a standing ovation: "Labels, we got you – but do you got us?"

The Grammy winner saw a 56 per cent increase in streaming of her album after her win.

Kayleigh Rose Roots

Chappell Roan has been Kayleigh Rose Amstutz's "pop persona" alter-ego since 2015 – when she was aged 17 – after two years of trialling various monikers.

The name Chappell Roan was inspired by her beloved late grandfather, Dennis "Papi" Chappell, and his favourite song, 'The Strawberry Roan'*, a western ballad written by Curley Fletcher in 1915.

*"Roan" is the term used to describe a horse that has a coat that is one solid colour, for example a "pinkish" brown, mixed with white hairs across its body.

❱❱ Honestly, picking my name was the hardest part out of it all because you're stuck with it once you pick it. I went through – I'm not kidding – thousands of names, and I always kept coming back to Chappell because it's a family name. And I found out I couldn't just be 'Chappell', as originally had wanted, so I picked Chappell Roan. ❱❱

Chappell Roan, *Unclear*, December 2017

21 December 2011

The date of Chappell's first gig, under the name Kayleigh Rose. She was 12. Chappell performed 'The Christmas Song', originally sung by Nat King Cole. The performance was part of a school talent contest at her school, Willard Middle School in Willard, Missouri, and it was the first time she had ever sung in public. And she won!

In December 2017, after signing her first record deal, Chappell returned to the school to perform the song again, telling the audience: "Today I got to perform... just like I did in 2011. It was very heartwarming to realize how many people support and love me and to see how far I have come. I am so grateful."

*

Off With Her Head(piece)

Following her immensely successful performance at Chicago's Lollapalooza festival on 31 July 2024, Chappell performed at the after show at the city's iconic Vic Theatre.

It was here, during 'Femininomenon' that Chappell walked out on stage in full Marie Antoinette-style regal corset ball gown, make-up and towering white hairpiece!

However, within seconds the over-sized wig toppled off Chappell's head and fell to the stage to reveal her real hair underneath. Chappell laughed the moment off – and now uses the bit as a hilarious skit in her shows!

19 February 1998

The day Chappell was born!

It was also the day that Usher's 'Nice & Slow'
hit the No. 1 spot in America's Billboard Hot 100.
The *Titanic* soundtrack was the No. 1 album in the
country –and sold a staggering 35 million copies,
making it the best-selling film score in history.

\\ **I feel like I'm just being my ten-year-old self. This whole project is to honour my ten-year-old self. My whole persona is just me trying to honour that version of myself that I was never allowed to be.** \\

Chappell Roan, *Paper*, June 2024

Amstutz

Chappell's birth surname, Amstutz, is a German word meaning "someone who lives at the foot of a steep mountain". How apt!

In her ten-year journey, Chappell has had to climb many steep mountains from her humble origins in Willard, Missouri to get to the peak of her pop success.

'Die Young'

In 2014, aged 16, Chappell uploaded her first
original song, 'Die Young', to YouTube under the
name Kayleigh Rose. The track is a "witchy"
ballad with heartbreak as its central lyrical theme.
It led her to be signed by Atlantic Records in
2015, aged just 17.

The track was influenced predominantly by
Lana del Rey, whose album *Ultraviolence* was
a massive inspiration while Chappell was at
a summer songwriting camp. Chappell now
cringes at the thought of the song. "It reminds
me when I was a very moody, angry teen!"
she told *Headliner* magazine in April 2021.

P!nk Beginnings

Chappell wears many of her influences on her sleeve, from legendary artists such as Dolly Parton, Elton John and Stevie Nicks, to contemporary artists such as Lady Gaga, Lorde and Lana del Rey. However, Chappell can still remember her first major memory that kickstarted her musical journey. "My mom got me my first CD – P!nk's *Missundaztood*. I listened to it *all the time*" (*Anchr*, April 2018).

Released in November 2001, when Chappell was just three years old, *Missundaztood* was a pop cultural phenomenon that sold more than 13 million copies!

1 August 2012

The day Chappell entered – and won! – a local talent contest at a venue called The Oasis, in Springfield, Missouri (it's on YouTube).

She sang Cyndi Lauper's classic 1986 hit 'True Colours'. As the winner, Chappell received a giant cheque for the princely sum of $1,012. Accepting the prize, the 14-year-old then told the audience, "I want to win a Grammy, and wI'm going to do whatever it takes to get it." Thirteen years later, she did.

Naked in London

Chappell's first live performance outside of the US was in London, UK, as part of her "Naked in…" tour. She performed on 12 June 2023 at the city's beloved The Garage in Highbury to a crowd of 600 fans. It would be two years before the UK would get the opportunity to see her live again.

Her setlist from the night:

1. 'Naked In Manhattan'
2. 'Love Me Anyway'
3. 'Femininomenon'
4. 'After Midnight'
5. 'Coffee'
6. 'Bitter'
6. 'Red Wine Supernova'
7. 'You Oughta Know' (Alanis Morissette cover)
8. 'HOT TO GO!'
9. 'Kaleidoscope'
10. 'Casual'
11. 'California'
12. 'Pink Pony Club'

School Nights

1. 'Die Young'

2. 'Good Hurt'

3. 'Meantime'

4. 'Sugar High'

5. 'Bad For You'

In 2017, Chappell released her debut EP entitled *School Nights*. Released on 22 September – on the one-year anniversary of her grandfather Dennis Chappell's passing – the EP is a five-song collection of acoustic folk ballads, and the first to be released under her stage name, Chappell Roan.

Lyrically, time plays an important leitmotif in the EP, and if you listen closely you can hear the sound of a ticking clock in every song.

"Yep, I made it"

It's often said that the first sign that you've made it as a superstar is on the first night of your first headline tour. For Chappell that night came on 19 August 2022, when she played New York's Bowery Ballroom – to just 600 people!

It was the night even she knew she had arrived as a star. "I had never performed my own music in front of that many people before," she told *Visit Springfield* (February 2023). "It felt very real, like everything had paid off for me. If I were to stop tomorrow, I'd be like 'Yep, I made it.'"

*

Pandemic Posts

Chappell has more than 45 million TikTok followers. During the COVID-19 pandemic and lockdowns, it was the platform that Chappell used to communicate with the world while living at home with her parents in Missouri.

"I got on TikTok to show my personality and how I love to thrift and have style and do make-up. And when I saw that people were not only connecting to the music but this DIY pop girl I was building, I was like 'Oh, I have a whole world that I can build. I just filled that out and used drag and burlesque as stakeholders,'" Chappell told *Dork* magazine (December 2023). Soon enough, she started gaining a lot of followers and used the outlet to hone her pop persona.

First Time on TV

On 20 June 2024, Chappell made her debut
TV performance on *The Tonight Show* with
Jimmy Fallon, singing 'Good Luck, Babe!'.
The performance showcased her authentic
and unique theatrical style, and the moment
is considered her mainstream breakthrough.

During the performance, Chappell wore a bright
white feathered swan costume, and during her
interview with the host, she swapped to a black
feathered swan costume: both representing
different sides of the artist.

" I wanted to push myself – I wanted to be bold and say things that might be a little edgy. I come from a super conservative area where I wouldn't even wear the things that I wear in LA here in public. So I decided I'm just going to be everything that I am in LA, in my music. "

Chappell Roan, *Headliner*, April 2021

31 July 2024

The day Chappell's 13-song set at Chicago's Lollapalooza festival in Grant Park drew the most-attended daytime set in the festival's history. More than 110,000 fans! And she wasn't even the headliner!

The performance was also the inaugural airing of a new song, 'The Subway'. Chappell dedicated, hilariously, 'My Kink is Karma' to her ex-boyfriend. "I found out he was bragging that he dated me at the bar in my hometown. This is a message to your fiancée – you should break up!"

Waiting for the One

After collaborating with Daniel Nigro on 2020's 'Pink Pony Club', Chappell knew she had found her perfect producer. However, in 2021, after the success of Olivia Rodrigo's 'Driving License', Nigro was pulled away from Chappell to produce Olivia's album, *Sour*. Chappell returned to live with her parents and save money until Nigro was available again.

The respect is mutual, as the producer told *Music Radar*: "Chappell is one of the greatest singers I've ever worked with. Her voice can do things that most singers can never do." (September 2024)

The duo resumed collaborating in 2022 and finished Chappell's album. "Dan always believed in me. He has been there from the beginning. Because he believed in me, I started to believe in me, too." (*New York Times*, October 2024)

'Good Luck, Babe!'

Chappell's first standalone single after the release of *A Midwest Princess*, 'Good Luck, Babe!', became her first song to enter the Billboard Hot 100, peaking at No. 4 in November 2024.

To date, the song has sold more than four million copies! It was also nominated at the 2025 Grammy Awards for Song of the Year, Record of the Year and Best Pop Solo Performance.

It is the only song of Chappell's – so far! – to break one billion streams on Spotify, a feat that the singer-songwriter called "Cuckoo loco!" on Instagram.

An Extremely Hooky Ride

Sandwiched in-between Noname's *Sundial* and Blondshell's self-titled masterpiece, *The Rise and Fall of a Midwest Princess* was ranked No. 12 on Rolling Stone's prestigious list of the "100 Best Albums of 2023". (No. 1 was SZA's *SOS*.)

The magazine called the debut a "wildly ribald, extremely hooky thrill ride," which "combines brutal honesty with unbridled passion in a way that sometimes startles, but always sounds luscious." Couldn't agree more.

"Every big thing that happens to someone's career happened in five months for me. It's crazy because things that I never thought would happen, happened times ten."

Chappell Roan, *Teen Vogue*, November 2024

"Olivia believed in me"

Chappell got her first taste of onstage success performing to more than 10,000 fans when she opened for Olivia Rodrigo on *Sour's* North America and Europe tour on 27 May 2022.

"The night before I played Olivia's show, I performed at this tiny bar for 200 people and then the next day, I opened for Olivia for 10,000 people! That's so crazy!"

Chappell did such a good job that Olivia promoted her to main opening act for her *Guts* world tour in 2023, performing more than 24 shows to more than 1.2 *million* fans. "Olivia believed in me," Chappell told *Visit Springfield*.

A Pinch of Stardust

If the title to Chappell's debut album *The Rise and Fall of a Midwest Princess* sounds familiar, it is because it is inspired by the 1972 album *The Rise and Fall of Ziggy Stardust and the Spiders from Mars*.

Ziggy Stardust was, of course, one of the many colourful characters created by the legendary British singer-songwriter, David Bowie. Chappell has revealed several times that her stage persona was inspired by Bowie's Ziggy Stardust, particularly his make-up: white face with an iconic red lightning bolt painted across his face.

DIY Queen

For the first few years of Chappell Roan's stage life, from 2015 onwards, her extensive make-up, costumes and wigs were all handpicked and prepared by the artist herself.

Before each show, Chappell would spend at least two hours getting into character, proudly calling herself a "DIY Queen". Chappell told Trixie Mattel during a *Paper* interview in June 2023, that she even did her own make-up for her album cover because she had "no money to pay a fucking make-up artist."

Today, Chappell has her own make-up artist, though the result is still the same: scrappy with a smidge of smudgy!

Chappell's iconic performance
at Coachella in 2024 was,
perhaps, the moment
when she truly arrived
as a femininomenon.

Her hour-long afternoon
set was broadcast live on
YouTube and amassed more
than 10 million viewers.
Though it was her opening
introduction, opposite, that
became the most iconic
moment of the set.

"My name is Chappell Roan. I'm your favourite artist's favourite artist. I'm your dream girl's dream girl. And I'm gonna serve exactly what you are: C*NT!"

Chappell Roan, Coachella Festival, April 2024

❝ **I wear grey and black IRL because I can't handle the shit at I wear onstage.** ❞

Chappell Roan, *Rolling Stone*, October 2022

High Notes

Chappell's vocal type is often considered a soprano, with a unique ability to be very theatrical and expressive within that range. Unlike several of her current contemporaries – except for trained singers such as Ariana Grande – Chappell can also employ what is known as her whistle register, as she has the capacity to hit the highest of notes. If you skip to 2.53 of 'After Midnight', you can hear Chappell's incredible whistle register. Wow.

"I grew up pretty much complete opposite of how I am now. "

Chappell Roan, *Illustrate*, June 2022

" With 'HOT TO GO!' and 'Femininomenon', those songs were difficult for me to put out because of how hateful people are. Some people just don't get the joke and don't have fun with music. They don't get the camp of it all; it's supposed to be silly, and it's not necessarily supposed to feel like serious music, you know? "

Chappell Roan, *Broadway World*, September 2023

Country Clown

Chappell's signature make-up of white face (with blue eyeshadow) is the singer's homage to the glam synth pop look of the 1980s.

However, Chappell's love of this look has a distinctly troubled origin that can be traced back to her childhood.

〞I started to do white
face because that's what
the country boys called gay
people in my hometown.
Clowns. I was just like,
'Bitch, I'll show you a
clown, if you want to
see a clown!'〝

Chappell Roan, *Paper* magazine, June 2024

Chapter Two

Alternative Kink

Famous Friends

Many famous friends have been at Chappell's side to help navigate her through fame and celebrity. In particular, Sabrina Carpenter. "We're both going through something so fucking hard ... she just feels like everything is flying, and she's just barely hanging on. It was just good to know someone else feels that way," Chappell told *Rolling Stone* (September 2024).

Elton John, the British icon, also checks in regularly with Chappell via FaceTime in order to keep an eye on her. "I am very protective of her," he said.

4.5 Billion

With more than 45 million monthly listeners on Spotify, Chappell is one of the most streamed female artists of all time. Her most popular song on the platform is 'Good Luck, Babe!', with more than 1.3 billion streams.

Hot on its heels is 'HOT TO GO!', with more than half a billion. Altogether, Chappell has amassed more than 4.5 *billion* streams since 2023. Incredible!

'Femininomenon' – I open the record with it. If you're not cool with this song, then you're probably not going to like the rest of it.

Chappell Roan, *Dork*, December 2023

Femininomenon

Released as the third single from her debut album, 'Femininomenon' – a "slumber party pop song" – is Chappell's mission statement and declaration of intent. "I've been dreaming of releasing a song like this my whole career," Chappell told *Earmilk* in August 2022. "It took years to build up the confidence to even sing in that style."

On 22 July 2024, the song had its biggest streaming day ever on Spotify, with more than 924,000 streams. It now has more than 250 million streams on Spotify.

"I'm not the character of Chappell Roan in real life."

Chappell Roan, *Teen Vogue*, March 2023

Amazing Alter-Ego

Chappell Roan is Kayleigh Rose's larger-than-life alter-ego. Or, as Chappell told *Vanity Fair* in September 2023, "She's a tacky version of me that's really fun to play, but it's very exhausting. If I could redo all of this, I would be Daft Punk. 10,000 per cent." (French duo Daft Punk hide their faces under robot masks to retain some privacy.)

Chappell got the idea to incorporate drag into her persona from the South African country superstar Orville Peck (who uses a mask as a disguise), after she attended his show at West Hollywood's iconic venue, the Troubadour in 2018.

The Rise and Fall of a Midwest Princess

Chappell released her debut album on Amusement Records on 22 September 2023. A slow burn, the album reached the US Billboard Top 10 nine months later. "The album represents me as a person," she told *Teen Vogue* in March 2023. "It's the story of a girl who moved from a small conservative town to a city and had an awakening of this world she never knew existed."

\\ **The Midwest influences everything. I don't want to lose that part of me. I thought I really did when I was younger, but now I don't anymore.** \\

Chappell Roan, *Variety*, September 2023

*

The Midwest

Midwest America, located between the Rocky Mountains in the west and the Appalachian Mountains in the east, runs from the Canadian border in the north to the Ohio River and the 37th parallel in the south. But do you know the 12 US states that make up the Midwest, often described as America's "Bible belt"? Answers below.

Illinois, Indiana, Iowa, Kansas, Michigan, Minnesota, Missouri, Nebraska, North Dakota, Ohio, South Dakota and Wisconsin.

"The raunchiness of the music as Chappell Roan is really liberating for me, because I have such a difficult time – as Kayleigh – with sex. I have a hard time watching sex scenes or flirting with people, I get really uncomfortable with hyper sexual things. But as the drag queen that I play, Chappell, she's not like that – she is very confident and comfortable singing about those things. "

Chappell Roan, *Polyester*, October 2024

Look at the Numbers!

In February 2022, two years after being dropped by her first record label, Atlantic, Chappell signed with Amusement Records, an imprint of Island Records, specifically created by her producer Daniel Nigro so he could sign the artist.

After being released by Atlantic, Chappell grew very "picky" about which new label to sign with following the sleeper success of 'Pink Pony Club'. "I probably have one of the best deals ever in modern music because I was like: 'Fuck you guys, give me what I want or I'm going to do this myself.' Now I can be like: 'Look at the numbers, bitch!'" (*The Face*, September 2024.)

'Good Hurt'

Chappell released her first ever single – 'Good Hurt' – as Chappell Roan in August 2017 via her then-record label, Atlantic. Her debut EP, *School Nights*, was released a month later. Chappell described 'Good Hurt', as a "dark-pop piano ballad", when she was 19 years old:

"When I sing, I want people to feel every emotion. All of my songs come directly from my personal experiences. 'Good Hurt' happens to come from a time when I was in a relationship, but wanted a different person who was toxic for me. The song is about me wanting something that I know is not good for me but I'm addicted to the pain."

Chappell Roan, *Interview*, August 2017

"The world is on fire, so let's just party."

Chappell Roan, *NME*, June 2023

Family Ties

Willard, Missouri, was a conservative Christian community that confused Chappell during her teen years. Feeling ashamed, and sometimes suicidal, Chappell acted out, making life at home hard. "I felt so miserable for my whole childhood," she told *Rolling Stone* (September 2024).

Feeling lost, Chappell's parents, Dwight and Kara Amstutz decided to enter family therapy together. "It saved us," Chappell said. "I was very mentally ill, and not medicated, for many years, because that's just not a part of Midwest culture. It's not: 'Maybe we should get you a psychiatrist.' It's: 'You need God. You need to pray about that,'" she told the *Guardian* in September 2024.

\\ I'm delving into this version of myself I never allowed myself to be, which is like this sparkly, tacky, loud, obnoxious version. Growing up I had this little girl trapped inside me that never got to express herself the way she dreamed of. \\

Chappell Roan, *Broadway World*, September 2023

LA Life

Chappell Roan came to life in 2018, aged 20, when she made a leap of faith and moved from Missouri to Los Angeles in order to pursue an acting career. The move made her question everything she knew to be true – about herself. Suddenly, her eyes were opened to so many new things that she never thought she was able to do. Chappell's epiphany that she was never going to write the pop songs she wanted to write while depressed and living on a rural farm in Missouri completely transformed her songwriting style. Soon, the bangers just fell out.

\\ **Before I moved to West Hollywood when I was 18, I had really never even seen a drag queen before. I'm in such awe of the make-up, the hair, the outfit, the dancing, the songs. It's just magical to me, and I just think it's the funniest thing ever to watch a drag show.** \\

Chappell Roan, *Salt Lake* magazine, August 2024

"Drag is like a spa for my soul.

Chappell Roan, *Guardian*, September 2024

Celebrating Campiness

Chappell began incorporating elements of drag into her "Chappell project" act from 2018, though she didn't call it specifically that until a few years later. Chappell felt that drag had all the "concentrated campiness" she needed to express herself live. "I just wanted a girl who was free and unapologetically herself," she told *Dork* (December 2023). "I wanted to create concerts where people could dress up and have a blast."

Drag, in America, exploded into the cultural consciousness for the first time with vaudeville acts at the turn of the 20th century, and then again with the phenomenal global influence of *RuPaul's Drag Race* reality TV show from 2009. In May 2024, RuPaul expressed admiration for Chappell by calling her "my current obsession".

Keeping it Together

In 2020, Chappell began to experience symptoms of hypomania, including manic episodes and hyperactivity, triggered by the success of 'Pink Pony Club'. Soon, Chappell could not sleep and began having suicidal thoughts. Just as she was about to open for Olivia's *Sour* tour in May 2022, Chappell entered outpatient therapy and was diagnosed with Bipolar II Disorder.

"It's been pretty hard to keep it together," she posted to Instagram in May 2022. "I don't really talk about it much, but it affects me daily and is a pretty big part of my music but I just wanted to share and I think it's important to talk about mental health."

Fame is just abusive.

Chappell Roan, *The Face*, September 2024

"I'm a thrift store pop star."

Chappell Roan, *Rolling Stone*, October 2022

Time Off

When Chappell is not busy being Chappell Roan, she's just Kayleigh Rose – but only to her friends and family. During Chappell's sacred time off, she can be found thrifting and crafting. She loves arts and crafts, such as needlefelt, sewing, crocheting, bedazzling, and will often host craft nights at her home and invite friends over. But that's not all. "My favourite thing to do is get really high and play Fortnite or Mario," she told *Vanity Fair* in September 2023. "I am very introverted. ... I love playing video games by myself."

'HOT TO GO!'

'HOT TO GO!' is a modern classic. "I wanted to be a cheerleader so bad. ... I never had the confidence to try out because I just thought... I didn't belong," she told *Vanity Fair* in September 2023. "But I wanted a cheer song. So literally what I did was Google classic cheerleading cheers."

The song was ultimately inspired by the 2019 Queen biopic *Bohemian Rhapsody.* As she told Brandi Carlile in an interview at the Grammy Museum in November 2024, "That scene whenever they're performing Live Aid and performing 'Radio Ga Ga'... that changed my career. I was like, 'I will do whatever it takes [to recreate that].'"

It's a cheer song, so there's a dance attached to it. It's like 'Y.M.C.A.' but gayer.

Chappell Roan, *Pop Crave*, February 2023

Tiny Desk, Huge Impact

Chappell's Tiny Desk performance is now regarded as one of the finest sets ever recorded for NPR's online concert series. Her 23-minute set, performed on 21 March 2024, solidified her status as America's most interesting artist. Her seven-strong all-female band, all dressed in neon pink, killed it too. Her performance – and towering wig! – was so mesmerizing it increased her Spotify monthly listeners count by 500 per cent! If you haven't seen it yet – check it out.

1. 'Casual'

2. 'Pink Pony Club'

3. 'Picture You'

4. 'California'

5. 'Red Wine Supernova'

"I got to this conclusion that I needed to be a tacky pop star. Also, I'm really attracted to sparkly things and cheetah print."

Chappell Roan, *Vanity Fair*, September 2023

Always Giving

March 2025's release 'The Giver' is Chappell's first since the release of 'Good Luck, Babe!' in April 2024. The single is the long-awaited teaser to Chappell's second album, a collection of songs that producer Daniel Nigro said would introduce "Chappell 2.0".

The track was first performed live on *Saturday Night Live* (SNL) in November 2024, her first appearance on the iconic sketch show. Fans were besotted immediately by Chappell's innovative take on country music... and use of the fiddle! "'The Giver' was such a fun song to write," Chappell told the Grammy Museum, November 2024. "I'm a country girl. So I got to be like, 'No, no, no, like, let me show *you* some country songs.'"

Call 620-468-8646*

*620-HOT-TOGO

This US telephone number was advertised all over US cities, such as New York's Times Square, with a huge billboard image of Chappell... looking *different* (slicked-back hair in a corporate bun, wearing a navy power suit). Those who dialled the number were treated to a variety of numbered options, such as booking a dentist or a plumber.

An Insta post announced the purpose of the advert: to promote her next single 'The Giver – Lawyer Edition'. "THE LAWYER – ur ex's worst nightmare + she gets the job DONE. Keep ur eyes peeled, she may be on a billboard in your town." Fans immediately presumed this new look was the unveiling of Chappell's new persona for her next set of songs. Did you ring the number?

Chapter Three

Euphoria & Sparkles

Catapulting Too Soon?

In May 2015, aged 17, Chappell signed to
Atlantic Records, home to some of the world's
biggest artists – Bruno Mars, Charli XCX,
Coldplay and Ed Sheeran. "I was 17 and
I thought I was gonna win a Grammy,"
she told *Rolling Stone* in October 2022.

Almost immediately, Chappell was uprooted
and sent on tour with Vance Joy (then Declan
McKenna), a move that triggered several mental
health concerns. As a result of signing with
Atlantic so young, Chappell also had to sacrifice
the end of her childhood. She didn't finish her
senior year. Or go to prom. Or graduation.

An Atlantic Mistake

Chappell's dream of being signed to Atlantic Records soon turned into a nightmare. She was promptly dropped in August 2020 after one release, her 2017 EP *School Nights*. The label cut her when they were unconvinced by Chappell's change in sound for 'Pink Pony Club'. "'We don't get it', they said," Chappell told the BBC in January 2025. While getting dropped was "the best learning experience", Chappell has since had the last laugh. "It feels so good to prove Atlantic Records wrong because they weren't just a little wrong. They were really, *really* wrong," she has said.

"I ask myself 'What would be the funniest thing to perform live?' That's how I write."

Chappell Roan, *Guardian*, September 2024

Depth + Drag

Underneath Chappell's drag queen persona are beautifully written lyrics that resonate with millions of people, many without a voice.

Chappell's songs are renowned for their hyper-specific lyricism, writing lyrics that feel akin to intimate diary entries, with pinpoint references of personal moments she either experienced, or desired to. Chappell herself has described her songs as "fairytale versions of real life." (*Vanity Fair*, September 2023)

Summer Sessions

When Chappell was 15 and 16 she attended the Interlochen Center for the Arts in Missouri for a summer songwriting camp. It was here that Chappell wrote 'Die Young'.

Even her camp counsellor was blown away by her "Lennon-McCartney-esque" songwriting skills. Surrounded by other creative "art kids like me", Chappell was able to find her voice, both singing and lyrically, for the first time, without feeling judged for being different.

Up until 2023, every summer, Chappell returned to Interlochen as a camp counsellor to give back to kids who are just like her.

While Chappell's followers have selected many fandom names for themselves over the years – anything from the Roan Rangers to Chappies to Chappellroanies – it seems they finally stuck to a name in 2023 with...

THE PINK PONY CLUB.

*

Crushing on Sasha

Chappell's favourite drag queen is, of course, Sasha Colby. In July 2024, Chappell got to meet Sasha for the first time and was overjoyed when she made Chappell a "Colby" – a super fan. "She's the best!" Chappell gushed. "Through this job I get to meet people I look up to a lot. Meeting Sasha made me feel really important and good about myself."

In 2012, Colby won the Miss Continental competition, one of the most prestigious drag queen pageants in the world, and in 2023, she was crowned the winner of Season 15 of *RuPaul's Drag Race* and became "America's Next Drag Superstar".

" **Drag has always been a mirror of pop culture. Since *Drag Race*, we are pop, the tastemakers, and pop girlies look to us for inspiration – much like Chappell Roan! All I can say is, goddess sees goddess, you know? Greatness sees greatness! Your favorite artist's favorite artist, baby!** "

Sasha Colby, *Entertainment Weekly*, July 2024
(after learning that she was
Chappell's favourite drag queen)

"I feel very myself on stage. I feel like that's what I was put on this Earth for – to throw fun parties."

Chappell Roan, *Salt Lake* magazine, August 2024

A Performance to Remember

With her all-female band – often dressed in full latex and silver sequins! – and supported by three local drag artists every night, Chappell's live shows focus on being 100 per cent fun.

Each night has a dress-up theme, from mermaids to Midwest, rhinestones to rainbows, pink cowgirl to angels versus devils. The themes, as Chappell herself has expressed, do present a problem for the future. "People love the themes so I do it for the people at this point because it really means a lot to them. But now I'm stuck in all these fucking themes!" she told *Rolling Stone* (September 2024).

\\ If I saw myself now when I was 16 I would be like no way there's no way I would do that. Let myself write a song that's about being a hot person and being a cheerleader, I'm too serious for that. \\

Chappell Roan, *Crucial Rhythm*, September 2023

Chappell made glorious global headlines on 11 September 2024, when she came out guns blazing to perform her new single 'Good Luck, Babe!' for the 2024 MTV Video Music Awards. The performance was Chappell's first ever big live award show set.

Dressed as a knight in armour, Chappell shot a fiery arrow with a crossbow, wielded a sword and set a castle on fire! "The song does not warrant me coming out with a weapon on fire, but I had to do it," she told the *Guardian* (September 2024). Later, dressed in chain-mail, Chappell won Best New Artist.

"I grew up thinking being gay was bad and a sin."

Chappell Roan, *Guardian*, December 2023

Out & Proud

Chappell's journey to sexual freedom, and discovering her sexuality, has been a hard-fought path. As a child, Chappell thought being gay was a choice and was deeply conflicted by her growing desires. For most of her adolescence, Chappell had been in a near-five- year relationship with a boy, despite knowing she was gay in seventh grade, around age 13. "I pushed down the gay part of myself so deep because I was like, that can't possibly be me," she told the *Guardian* (September 2024).

Today, her music is a "vessel" to the LGBTQIA+ community to which she proudly belongs. "My songs have allowed me to be in a room with all these queer people who are experiencing joy – and the songs have been a way for me to find those things in myself," she told *The Forty-five* (January 2024).

Chappell Roan

Sound of the Year

In January 2025, Chappell was announced as the BBC's Sound of 2025, a highly acclaimed prize chosen by a panel of more than 180 musicians and experts, including Sir Elton John, Dua Lipa and Sound of 2014 winner Sam Smith.

Over the years, many rising stars have been awarded the title, including Adele, Ellie Goulding and HAIM. Chappell beat shortlisted contenders Ezra Collective, Barry Can't Swim, Myles Smith and English Teacher to the 2025 title.

〝I grew up pretty much complete opposite of how I am now.〟

Chappell Roan, *Illustrate*, June 2022

'Pink Pony Club'

If there's one song in Chappell's catalogue that defines the singer more than any other, it's 2020's 'Pink Pony Club', a club banger that dropped at the height of a global pandemic – when all the clubs were shut!

"It was the worst possible timing," Chappell has said (and even then the release had been delayed for two years). "But that song changed everything. I never thought I could actually be a 'pop star girl' and 'Pink Pony' forced me into that."

The song's inspiration comes from Chappell's visit to the iconic gay bar, The Abbey in West Hollywood; although the song's title is taken from the Pink Cadillac, a strip club in Springfield, Missouri. The building's exterior was painted in a vibrant hot pink! Chappell always adored the building every time she passed it, but never realized it was a strip club...

Headliner

In December 2024, Chappell announced that she would headline her first ever festival, the UK's historic Reading & Leeds three-day festival in August 2025. Announcement of the festival shows energized Chappell's fans into a frenzy, as they immediately presumed that the singer would perform, possibly headline, at Glastonbury in June 2025.

Pig Prosthetic

Chappell has worn a feast of fabulous costumes in recent years for various award shows and ceremonies, from a red mermaid dress, a Statue of Liberty-inspired dress, a *Poor Things*-inspired corset, an '80s prom dress, an "Eat Me" T-shirt and, who could forget, the Impossible Butterfly.

Most memorable of them all has to be the prosthetic pig nose look, known as "Penelope", that Chappell rocked for the 'Good Luck, Babe!' cover art and the Grammy Awards After Party in 2024. "I loved the prosthetic pig nose," Chappell told *Atwood Magazine* (August 2024). "That felt very daring and was kind of scary, in a fun way."

Frida Kahlo

Chappell is inspired by the artworks of Mexican artist, Frida Kahlo, her favourite painter. "I love the darkness and vulnerability of her paintings," she told *Anchr Magazine* (April 2018).

There are several parallels between Kahlo (1907–1954) and Chappell. Kahlo was celebrated for her surreal self-portraits exploring identity, suffering and feminism – much like Chappell's lyrics – a result of her lifelong health struggles, including depression.

> I didn't see myself as queer growing up at all. I felt that I was only meant to be a mother or a wife and a loyal woman of God, and if I wasn't those things then I was nothing.

Chappell Roan, *Salt Lake* magazine, August 2024

OG Chappell

While all of Chappell's family have been incredibly supportive of Chappell's rise to superstardom, it was her maternal grandfather Dennis K. Chappell that she took a lot more inspiration from than just her stage name. And while he passed in 2016, Chappell moves forward with him in her heart. Her belief in herself comes from his belief in her.

"He was very funny and very smart," she told the BBC in January 2025. "He never questioned my ability. A lot of people told me, 'You should go completely country', or, 'You should try Christian music'. And he never told me to do anything but be myself. He was the only person who told me 'You don't need a plan B. Just do it.'"

Chapter Four

Femininomenon

\\ I just wanted to feel like a good person, but I had this part of me that wanted to escape so bad. I just wanted to scream. I snuck out a lot, but I still went to church three times a week. So it was just this dichotomy of trying to be a good girl, but also wanting to freaking light things on fire. \\

Chappell Roan, *Variety*, September 2023

No Thanks

With an instinctual flare for the theatrical,
Chappell began taking acting classes in
Springfield before moving to LA in 2018. While
Chappell has said several times she would
"rather get arrested" than act, she now turns
down more lead acting roles in films than ever.
"I've been asked in the past couple of weeks,
'You want the lead in XYZ?' and I'm like,
'No. I say this with peace, and love, and
blessings but actors are fucking crazy!'"

"Ramisha is just as much Chappell Roan as I am. "

Chappell Roan, CNN, October 2024

The Woman Behind the Scenes

Ramisha Sattar, Chappell's Creative Director
began working with the star in 2022. At first,
Ramisha designed Chappell's merchandise
and was a wardrobe assistant, but today
she is in charge of Chappell's visual output
and makes sure everything the singer does
"all feel like Chappell".

From sourcing vintage items and fabrics to
creating the animations for the live shows
to choosing make-up and outfits, Ramisha
is Chappell's right-hand woman. "She has the
vision behind my aesthetics, merch, and the
feeling of campiness. She brings the camp to
the project. That is very rare and it needs to be
spotlighted," Chappell has said of Ramisha.

Ramisha was nominated for a Grammy in 2025
for Best Recording Package, for Chappell's
album and its paper doll kit, which she designed.

\\ **In my artistry, drag fuels everything. Drag is camp and camp is the most fun thing in the world, and that is what I want my project to feel like. Drag has always been a part of society, whether or not people know it. It's been around for so long. I love that it's becoming mainstream. It's such a strange time, but also amazing because drag is blossoming faster than it ever has.** \\

Chappell Roan, *Atwood Magazine*, August 2024

Gothic, Feminine & Eerie

Chappell's first ever nationwide press review, for her debut single 'Good Hurt', was written for *Interview*, August 2017, and released a month before her debut EP *School Nights*.

"Her pop sound is infused with a dark and unsettling tone that underscores her intense, sombre lyrics, and she has the aesthetic to match it: gothic, feminine and eerie – all safeguarding the young artist's mystique. Given such a wide range of interests, combined with striking maturity and surprisingly deep vocals, we expect intriguing material from the blooming artist in the near future. 'I want them to know who I am,' promises Roan, and surely, we will."

It would be another five years before the world suddenly started paying proper attention.

Queen of Drag

It was on 12 June 2023, when Chappell was performing at The Garage, London, that she first had the epiphany that she was indeed a drag act. That night, two queens, Crayola the Queen and Mahatma Khandi, opened for Chappell.

It was when Crayola told Chappell, "*You're* a drag queen. You know that, right?" that Chappell first realized that her costumes and make-up were all just her own version of a drag queen act.

"I was like, 'Oh my god. That's what this is!'" she said. "I just happen to perform drag to my own songs. Chappell is a drag-queen version of myself." Ever since the realization, Chappell has immersed herself even further in dragdom; the moment sparked Chappell's inspiration for the album cover: Chappell dressed in her own DIY drag costume and make-up.

\\ **When I hit 24, that's when I started liking myself enough to become this drag version of myself.** \\

Chappell Roan, *Line of Best Fit*, 22 June 2023

Your Favourite Artist's Favourite Songs

In an interview with *Rolling Stone* in September 2023, Chappell revealed her five favourite songs… and why they are extra-special.

'Guilty Pleasure'

"'Guilty Pleasure' is my favourite. It just feels so good at the end. It's just party. It just feels like euphoria. It's about when you like someone but they don't know it yet. We get dressed together in our swimsuits, and it's OK if we're naked. But then you're like, 'Oh, fuck, you're my best friend and this is weird and it's my guilty pleasure.'"

'Super Graphic Ultra-Modern Girl'

"It's an undeniable gay pop song. I literally was inspired by an *Architectural Digest* video. I don't even remember who it was, but this lady was talking about the architecture of this house. And she's like, 'It's just super graphic and it's ultra-modern.' I don't know why, but I was like, 'ding.' I wrote it down."

'Kaleidoscope'

"This one I wrote 100 per cent myself. I'm really proud of it. That song was written in three hours because I just had so many feelings. I had told my best friend the night before that I was in love with her. We were dancing on the dancefloor and I started crying and we just started making out. And I was like, 'I'm queer. This is what love feels like.'"

'Picture You'

"I was in an online relationship for a few months where all we did was sext. And I wrote that song based on that. Like 'Do you picture me like I picture you in my head?' I made up so much! When you're in an online relationship, You're just fantasizing. And so 'Picture You' is that fantasy. I really love this song, I feel like it showcases my vocals in a way that no other song does on the record."

Chappell Roan

The Year of Chappell

2024 will go down in history as the "Year of Chappell", especially in terms of her impact on popular culture.

From the perspective of album sales, Chappell ended up just outside of the Top 10 best-selling artists of the year – at No. 11 – and was the fifth best-selling female behind SZA, Billie Eilish, Sabrina Carpenter and Taylor Swift. Her debut album, as of March 2025, has sold more than two million copies.

As for Top New Artist, Billboard announced Chappell the year's winner sales-wise, beating Benson Boone, Shaboozey, Teddy Swims and Tommy Richman to the title.

*

For the Gworls

Throughout Chappell's "Midwest Princess" North American tour of 2023/24, Chappell donated $1 per ticket sold to the Black trans-led collective FOR THE GWORLS.

To date, Chappell has raised through more than $500,000 across 94 shows.

The charity has a special place in Chappell's heart as it raises money to assist Black trans people to pay their rent and affirmative surgeries. "... As we grow, [I] want to grow the payment of the queens [who perform with me every night]. Also, a portion of every ticket goes to FOR THE GWORLS," Chappell told *Atwood Magazine* (August 2024). "I want to do that for the rest of my career."

Rodrigo x Roan

Working in the same studio as Olivia Rodrigo during the recording of her album *Guts* (while also sharing the same producer, Daniel Nigro) meant that it was inevitable that the two singers joined forces. Chappell sang backing vocals for three songs for Olivia's 2024 effort, including one song from 2023's *Hunger Games: Ballad of Songbirds and Snakes* soundtrack. Do you know which? Answers below.

"We all work out of the same studio and Dan is like 'Can you come help?' So I go over there and sing harmonies. I love that Olivia's open to having another vocalist," Chappell told Capital Buzz (January 2024).

'Lacy', 'Obsessed,' and 'Can't Catch Me Now.'

\\ **I always try to push myself and how I write pop music. I want to see if I can get away with being as ridiculous as I possibly can.** \\

Chappell Roan, *Earmilk*, August 2022

\\ I feel like I represent the queer kid in the Midwest that broke out... and just became a fucking dragon. \\

Chappell Roan, *Rolling Stone*, September 2023

America's Got Talent

In 2012, Chappell auditioned for the US's most-watched singing TV competitions, *America's Got Talent* and *The Voice*, each with more than 10 million viewers per episode.

During the ATG audition, Chappell sang her rendition of Alanis Morrisette's 'You Oughta Know', one of her favourite songs from her biggest idol, a song she loves to "belt out". Unfortunately, Chappell did not progress for either talent show to the audition rounds. "I had no idea what I was doing," she told *Springfield News* in 2017.

Chappell Roan

"We're just a
very normal
household."

Chappell Roan, *Springfield News*, 2017

Sibling Love

Did you know that Chappell is the oldest of four siblings? She has a younger sister named Kamryn and younger brothers named Dawson and Drew. They were her special guests when Chappell performed the debut live outing of 'The Giver' on SNL in January 2025. Will any of them follow their sister's high-heels into a famous music career?

Faces of Music

A three-part Hulu docuseries, in collaboration with Sephora, premiered in January 2025. *Faces of Music* explored the connection between beauty, music and identity. Naturally, Chappell was invited to be its first guest, and called the collab with Sephora a "dream come true". On the episode, Chappell recreated the drag look from her album cover and discussed how she meticulously constructs her pop persona. It's a fascinating watch, as Chappell reveals, "I am inspired by artists who create ecosystems for their projects."

\\ **My strongest influence is definitely '80s synth pop. I love weird sounds. I love dance and anthemic pop. Queen and Madonna vibes. But my biggest idol is definitely Alanis Morisette. She's so amazing. Everything about her I love.** \\

Chappell Roan, *Illustrate*, June 2022

7,000

The number of copies Chappell's debut album, *The Rise and Fall of a Midwest Princess*, sold in its first week in the US in September 2023. Just 7,000!

However, it became the fifth most streamed album in America in 2024.

9 August 2024

The day Chappell celebrated her first-ever official No. 1 album – in the UK Album charts – a year after *The Rise and Fall of a Midwest Princess*'s original release.

By the end of the year, the album was confirmed as the UK's biggest debut album of 2024 and the best-selling debut album on vinyl in 2024, overtaking the mighty Taylor Swift.

The Fame Monster

Much has been written about Chappell's feelings about "the fame monster" and celebrity. In a few short years, Chappell has had more than her fair share of creepy and obsessive fans, toxic abuse and harassment – and has asked for it to stop several times before it goes too far.

Daniel Craig, the iconic actor, praised Chappell's venting. "I really admire her for having the guts to say those things," he told the *New York Times* in January 2025.

On 23 August 2024, Chappell – exhausted, scared and angry – posted a lengthy message to Instagram. She had had enough of toxic fan behaviour. The message went viral, and millions of true fans expressed their love. Chappell wrote:

"I chose this career path because I love music. I do not accept harassment of any kind because I chose this path, nor do I deserve it. I don't agree with the notion that I owe a mutual exchange of energy, time, or attention to people I do not know, do not trust, or who creep me out – just because they're expressing admiration."

The behaviour of many obsessive fans had grown so bad that Chappell threatened to quit music entirely.

Work Out

For many years, Chappell has carried out daily "cardio vocal training" to ensure she is fit enough to be able to run and sing on stage at the same time, a gruelling task!

Every day, Chappell runs her entire 80-minute set in order while doing a high-intensity cardio workout. "I sing and run and do burpees, jump squats, jump rope, high knees... until I don't feel like I'm going to throw up anymore!" Chappell told radio station 1824 in December 2024.

During her teens at high school, Chappell was a cross-country runner and even qualified for the Missouri State Cross-Country Championships. Her personal record for a 5K run is very impressive – 20 minutes!

⟍ I love vegetable pizza the most, but I can't possibly miss the opportunity to call my own pizza Chappellroanie Pepperoni. It's just too perfect. ⟍

Chappell Roan, *I Dream of Vinyl*, May 2020

"Five words to describe me? I would say rhinestone, explosive, innovative, bold and feminist."

Chappell Roan, *Pop Crave*, February 2023